GIVING THANKS

The Gifts of Gratitude

M. J. RYAN

Conari Press

First published in 2007 by Conari Press,
an imprint of Red Wheel/Weiser, LLC
With offices at:
500 Third Street, Suite 230
San Francisco, CA 94107
www.redwheelweiser.com

ISBN-10: 1-57324-317-5
ISBN-13: 978-1-57324-317-9

Library of Congress Cataloging-in-Publication Data available upon request

Cover and interior design by Maija Tollefson
Cover photograph © Mitch Hrdlicka/Getty Images
Interior photographs: pages 6, 8, 16, 20, 30, 35, 66, 72, 74, 78, 86, 90,
108, 109, 110, 116, 112, and 173 © Alison Miksch/Brand X Pictures; pages
13 and 19 © *Pregnancy & Babies*/Photodisc; pages 38 and 102 © Daniel
Talbott; pages 25, 50, 56, 63, 97, and 126 © Helen Wolkerstorfer; pages 10
and 69 © aheinzen/iStockphoto; page 170 © manley099/iStockphoto; page 52
© digital_eye/iStockphoto; page 49 © FEMWorks/iStockphoto.

Printed in China
MD
10 9 8 7 6 5 4 3 2

CONTENTS

Life will bring you pain all by itself. Your responsibility is to create joy.

— MILTON ERICKSON, M.D.

INTRODUCTION

If you look to others for fulfillment, you will never truly be fulfilled. If your happiness depends on money, you will never be happy with yourself. Be content with what you have; rejoice in the way things are. When you realize there is nothing lacking, the whole world belongs to you.

—LAO TZU

Do you know that happiness, the sheer joy in being alive, is within your reach? All you need is an attitude of gratitude. Gratitude creates happiness because it makes us feel full, complete; it's the recognition that we have all we need, at least in this moment.

Recent scientific research has begun to indicate that positive emotions, such as gratitude and love, strengthen and enhance the immune system, enabling the body to resist disease and recover more quickly from illness, through the release of endorphins into the bloodstream. Endorphins are the body's natural painkillers. Among other effects, they stimulate dilation of the blood vessels, which leads to a relaxed heart.

What this means is that the more we experience a sense of gratitude, we literally bathe ourselves in good hormones and feel happier and more content with our lives. Like most great spiritual truths, gratitude is stunningly simple. This is not to say it's necessarily easy to practice. All kinds of distractions, obfuscation, and negative attitudes from our upbringings may get in the way. But all you really have to do to receive gratitude's gifts is make a commitment to be thankful on a daily basis, and the world will be suddenly transformed into a beautiful wonderland in which you are invited to play.

PART 1

the gifts of gratitude

Gratitude unlocks the fullness of life. It turns what we have into enough, and more. It turns denial into acceptance, chaos into order, confusion to clarity. . . . Gratitude makes sense of our past, brings peace for today, and creates a vision for tomorrow.

— MELODY BEATTIE

Consciously cultivating thankfulness is a journey of the soul, one that begins when we look around us and see the positive effects that gratitude creates. We do this by noticing those around us to whom gratefulness comes easily and realizing how much we enjoy being around these people.

We also tap into these gifts as we think about times in the past when we felt particularly grateful. Remember the peacefulness and the delight that accompanied those times? As we come to understand the gifts of gratitude, we realize that being grateful is not something remote or foreign, but part of the natural joyful expression of our full humanness.

In humble moments when we can no longer gloss over the roughness of life, gratitude has a way of pushing out the real soreness of feeling cheated or inadequate to the rugged realities of the world. Gratitude seemed to be a handy response to dodge the tough things for which there are no simple or comforting answers.

—PATRICK J. MALONE

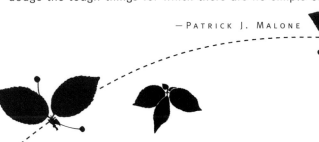

Take a few minutes to reflect back on a happy moment in your life that stands out for you, a moment that stays with you, even if it happened ten, twenty, forty years ago. Experience it again—see the scene, hear the sounds that were around you, feel the sensations. What was it about that moment that stays with you? What was going on for you that allowed you to feel grateful?

That's the most wonderful thing about gratitude—it makes you feel full, bursting with delight, just to remember the gifts you have received. Thus are we doubly blessed—when we receive something, for the gift itself, and later, in recall, for the miracle of having been given it.

Can you see the holiness in those things you take for granted—a paved road or a washing machine? If you concentrate on finding what is good in every situation, you will discover that your life will suddenly be filled with gratitude, a feeling that nurtures the soul.

—RABBI HAROLD KUSHNER

One of the incredible truths about gratitude is that it is impossible to feel both the positive emotion of thankfulness and a negative emotion such as anger or fear at the same time. Gratitude births only positive feelings—love, compassion, joy, and hope. As we focus on what we are thankful for, fear, anger, bitterness simply melt away, seemingly without effort.

How can this be? The answer is that gratitude helps us track success and the brain naturally works to track success. If you have ever watched a baby learn something, you'll know what I mean. Learning to walk, for example, she stands and puts out one foot. Boom! Down she goes because her balance wasn't right. Instead of castigating herself for blowing it, getting angry, or blaming the floor or her shoe, she just registers that it didn't work and tries again.

As we get older, however, we get schooled in our mistakes, and learn to focus on what's lacking, missing, inadequate, and painful. That's why gratitude is so powerful. It helps us to return to our natural state of joyfulness where we notice what's right instead of what's wrong. Gratitude reminds us to be like plants, which turn toward, not away, from the light.

Joy is prayer—Joy is strength—Joy is love—Joy is a net of love by which you can catch souls. She gives most who gives with joy.

—MOTHER TERESA

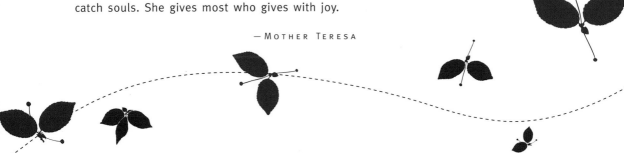

I don't know about you, but in general, there hasn't been a lot of joy, that opening and swelling of the heart, in my life. It wasn't because of my circumstances, because they weren't particularly hard, but because of my mental training. Like so many of us, I was busy climbing the ladder of success, and took no time to enjoy the journey. I was too busy getting on to the next challenge. But I got sick and tired of a joyless existence, and so have thought a lot in the past few years about how to bring more joy into my life. The more I think about it, the more I believe that joy and gratitude are inseparable. Joy is defined by the dictionary as an "emotion evoked by well-being, success, or good fortune or by the prospect of possessing what one desires," while gratitude is that "state of being appreciative of benefits received." In other words, whenever we are appreciative, we are filled with a sense of well-being and swept up by the feeling of joy.

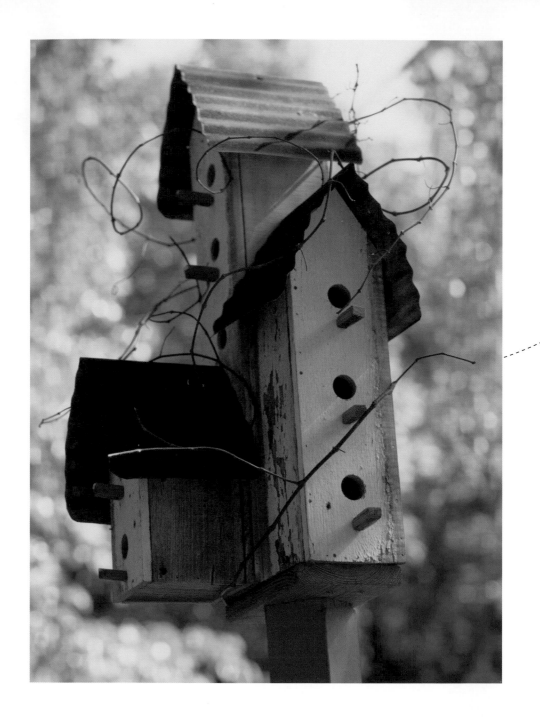

Begin today. Declare out loud to the Universe that you are willing to let go of struggle and eager to learn through joy.

— SARAH BAN BREATHNACH

Want to feel more joyful? Take a moment right now to think of all that you have accomplished today and celebrate each feat, no matter its size. You feel better, even if only a little bit, right? The more we pay attention to our successes and accomplishments, the more success we can create. And we'll view life as a grand adventure that we're willing to show up for rather than a series of tedious tasks to be crossed off or endured.

The invariable mark of wisdom is to see the miraculous in the common.

—RALPH WALDO EMERSON

Young children are such exuberant, joy-filled creatures, eager to embrace life in all its mystery and majesty. Everything is new, exciting, a gift—a bubble, a snowflake, a mud puddle. But something in the process of growing up so often takes the juice out of us. We become encrusted, hard, jaded. We lose our joy, our exuberance, our passionate embrace of life. We trudge instead of skip, retreat instead of explore, "too old for that," whatever "that" is.

This drying up is so common that when we meet a vibrant, joy-filled older person, he or she stands out as a singular exception. But we don't have to lose the happiness or juiciness of youth. All we need to do is to tap into our sense of gratitude, for when we do, we are like little children again, seeing the world for the first time.

Gratitude is the fairest blossom which springs from the soul.

—HENRY WARD BEECHER

In *Simple Pleasures of the Garden*, Dawna Markova shares a story about a woman who has kept her attitude of gratitude alive: "Several years ago, I was walking in March along a gravel road that led to the ocean in Rhode Island. A very old and thin woman came hobbling down a driveway toward me. I waved and continued walking, but as I passed, she grabbed my arm, turned around and began to pull me in the direction of her house. I instantly thought of the witch in *Hansel and Gretel*, and tried to pull back, but that only made her clutch tighter around my wrist. Besides, she didn't cackle, so I relented.

"She didn't say a word, in fact, until we approached her house: a shingle-style cottage with green shutters and a front lawn erupting everywhere in purple crocuses. She released me there, throwing her arms up in the air and shouting, 'Look at this splendor! Isn't it a miracle?!'"

Mental sunshine will cause the flowers of peace, happiness, and prosperity to grow upon the face of the Earth. Be a creator of mental sunshine.

— GRAFFITI ON A WALL IN BERKELEY, CALIFORNIA

Gratitude makes us feel good because it helps us widen our frame of vision. Under depression or stress, we can develop tunnel vision, seeing only this problem, that difficulty. We can get overtaken by a heavy, dark feeling of despair. But when we experience a sense of gratitude, we give ourselves a dose of mental sunshine. Suddenly the world seems brighter, and we have more options.

And the greatest thing is that as we experience the mental sunshine of gratitude, we begin to glow with sunshine ourselves. Suddenly not only is the world brighter, but we are too. Soon we notice that our lives are full of people who want to be around us because we exude peacefulness, happiness, and joy.

You cannot be grateful and unhappy at the same time.

— A WOMAN TO DR. TOM COSTA

Tapping into the wellspring of gratitude is the greatest antidote to worry I have ever experienced. How come? First, worry is always about the future, if only the next hour or minute, whereas gratitude is in the here and now. Cast over your list of worries. Aren't they always about what might or might not happen? You are worried about the reaction of your boss tomorrow to your presentation. You're worried about how you are going to afford to send your son to college. You're worried about the test results. In every case, you project yourself into the future and imagine something bad happening. Gratitude brings you back to the present moment, to all that is working perfectly right now. Tomorrow may bring difficulties, but for right now, things are pretty good.

It is not hard to live through a day if you can live through a moment. What creates despair is the imagination, which pretends there is a future and insists on predicting millions of moments, thousands of days, and so drains you that you cannot live the moment at hand.

— ANDRE DUBUS

Gratefulness eliminates worry because it reminds us of the abundance of our universe. It helps us remember that we've had many blessings in our lives. Yes, something bad might happen, but given all that you have received so far, chances are you will continue to be supported on your journey through life, even in ways you would never have guessed or chosen for yourself.

Sometimes I go about with pity for myself and all the while Great Winds are carrying me across the sky.

— OJIBWAY SAYING

When we are grateful, we exude happiness and that makes us magnets that draw other people toward us. They want to be around that exuberant energy. Gratitude not only draws people to us, but it helps us keep those who are in our sphere. When we see the glass as half-full, rather than half-empty, we notice what is there, rather than dwelling on what is not. When we notice what's there, we get out of our self-absorption and realize that there *are* people around us, many of whom have done wonderful things for us. And when we express our gratitude for their presence in our lives, it's more likely that those people will want to continue to be around us.

A point worth pondering: Upon completing the Universe, the Great Creator pronounced it "very good." Not "perfect."

—SARAH BAN BREATHNACH

When I was young, I wanted to be a saint. Not just plain old good, but a bona fide canonized saint. I figured that anything worth doing was worth doing perfectly, and while I was being perfect, I might as well get all the adoration that perfectionism deserves. Sainthood seemed to fit the bill. Unfortunately, I kept slipping up—I would forget to make my bed or get jealous of my little brother, and then sink into despair, convinced I was a complete failure.

Ah, perfectionism! Those of us afflicted with the pesky bug may look with amazement (You mean you don't care you didn't do it perfectly??) or disdain (What kind of lazy, good for nothing guy *are* you?) upon those who don't suffer from it, but the truth is, of course, that it springs from our own sense of lack. We simply don't believe we're good enough as we are in our humble, human, imperfect state, and must therefore compensate by being Miss Perfect Goody-Two-Shoes.

That was certainly true for me. Somehow, as a child, I got the message that if only I did everything perfectly, life would be OK. But life has a way of being messy and imperfectable, despite our best efforts, and individuals, including

myself, are equally incapable of perfection. After decades of sainthood wannabes, I finally got worn out from trying. Now, instead of attempting to make everyone and everything fit my plan (an impossible task, even for a saint), I spend the energy I used to use in sainthood school to be more grateful.

Because perfectionism is born of a sense of inadequacy, a lack, an attitude of gratitude counteracts it by tapping us into the experience of abundance. Gratitude makes our world feel complete and right. When we feel the fullness of gratitude, we accept life just as it is—however messy, complicated, and drawn-outside-the-lines that may be.

Gratitude not only helps us accept that the world is imperfect, but that we are too—and that's OK. For when we pour the oil of appreciation for life in all its imperfections over our experience, we ourselves can't help but be anointed. Suddenly seized by joy for the crazy, mixed-up world, we recognize ourselves as part of that world, and take our rightful place as a child of the Universe, perfectly acceptable in all our imperfection.

So if you've been bitten by the "P" bug, try the gratitude antidote and see whether it helps you give yourself a break.

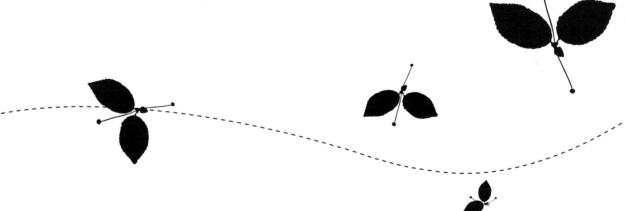

The more light you allow within you, the brighter the world you live in will be.

—SHAKTI GAWAIN

Have you ever met someone so bitter and resentful about their life that they feel like a black hole sucking away all the energy around them? Whether we call them pessimists, ingrates, or those who always see the glass as half-empty, they are a drag to be around. So focused on what hasn't worked for them, how life or other people have mistreated them, they can't see all the ways they have been the recipients of gifts, blessings, and wonderful surprises.

Most of us aren't total black holes, but when we fail to give thanks for what happens in our lives, we can get hung up in bitterness that prevents us from developing emotionally and spiritually. If we fail to grow, the light inside us grows dim. Gratitude is an inner light that we can use to illumine our souls. The more we are thankful, the more light we experience and the more we shine forth into the world.

If there is to be any peace it will come through being, not having.

—HENRY MILLER

A perennial dieting tip is to eat something and then wait twenty minutes before deciding to eat something again. The reason is that your body needs that much time to register that it is full. If you keep eating without pausing, you will not realize that your body is full, and therefore you may overeat.

Giving thanks for what we have in our lives is like that pause when eating. It allows us to feel full, to register on the emotional and spiritual level that we have, in fact, been given "enough." If we don't practice gratitude on a daily basis, it's easy to overconsume, to feel a lack and to try to fill that lack through possessions, because on a psychological level we haven't registered that we already have what we need.

That it will never come again is what makes life so sweet.

— E M I L Y D I C K I N S O N

Last night I watched my daughter Ana, whom we recently adopted from China, lie on the bed in an ecstatic trance of bottle sucking. Her eyes closed, her rosebud mouth pursed, her exquisitely long fingers curled around the plastic bottle, she gave herself over to the experience. She wasn't obsessing on past wounds, although perhaps she had a right to. Neglected for over a year, when we got her she had been covered with second-degree burns on her buttocks from lying in urine. Nor was she worrying about where the future bottles might come from, although she had a right to do that also. Abandoned on Christmas evening on a cold street until someone heard her newborn cries, she had been fed only watered down milk and seemed to be starving the first few weeks we fed her.

Rather, she was so focused on appreciating the warm milk as it went down her throat that everything else, past and future, simply disappeared. As I looked at her, I realized that this total and complete absorption in the present moment is available to us all when we choose to let gratitude wash over us uninhibitedly.

Realize deeply that the present moment is all you really have.

— ECKHART TOLLE

As I allow myself to open to the fullness of gratitude, the past and future do fade away, and I become more alive in the present moment. That's because gratitude is, for the most part, about the here and now. While we can be thankful for past blessings and hope for future ones, when we experience a sense of gratefulness, we are usually contemplating some present circumstance. We are brought up to date with ourselves, so to speak. Our focus moves away from all that we or others did or failed to do in the past, or what we hope for or worry about in the future, and we find ourselves placed squarely in this precious moment, this experience that will never happen again.

The most invisible creators I know of are those artists whose medium is life itself. The ones who express the inexpressible—without brush, hammer, clay or guitar. They neither paint nor sculpt—their medium is their being. Whatever their presence touches has increased life. They see and don't have to draw. They are the artists of being alive.

—J. STONE

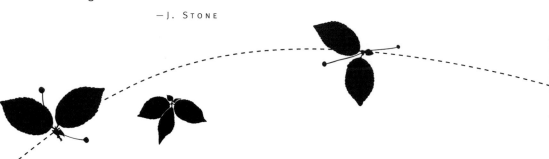

I spent several Christmases recently with a family that loves to give presents. Every year, the floor around the tree was heaped with hundreds of gifts, so many that it took the entire morning to open them all. But despite all that was given and received, I would leave there every year feeling empty and alone. There had been a plethora of presents, but no presence. This family gave so many gifts because they didn't know how to connect deeply to themselves and one another. And they ripped through the mounds of merchandise, saying a pro forma "Thank you," but with no sense of true appreciation being expressed or received.

The experience was so powerful—the contrast between the material plenty and the emotional lack—that it set me to thinking. That's when I realized that you can't experience gratitude with a heart that's closed. It's just not possible. That's because gratefulness is only experienced in the moments in which we open our hearts to life—to the beauty in this moment, to the possibility of surprise in the next.

Gratitude is the most exquisite form of courtesy.

—JACQUES MARITAIN

A person does something kind for you, it could even be a very small thing, say holding a door open for you. When you say, "Thank you," *and really mean* it, rather than saying it out of social convention, your heart instinctively opens to the person. In that moment, you experience your connection to each other, even if you never lay eyes on each other again.

This openheartedness takes courage. It requires enough trust in the goodness of other people and the universe at large that we can put aside our self-protectiveness—that stance that says I am not going to be grateful for what I am receiving right now because it's too scary to risk getting hurt—and take a leap of faith to acknowledge that we have received a gift.

The fact that true gratitude creates a sense of openheartedness is the reason so much of the "thanks" in this culture is rote and unfeeling. People are afraid to feel thankful, because they are afraid of the out-of-control experience that occurs when they acknowledge the bond between giver and receiver. We are afraid to feel the love that gets created any time we express true thanks. As adults, our hearts have been broken many times and, by golly, we want to make sure it doesn't happen again.

The choice is ours, in every moment. Do we want to live in seeming safety, shut inside the shell of our individuality, unwilling to experience the deep and abiding connections that are ours in any case, or are we willing to risk, over and over, having our hearts broken open to the beauty and the pain of all that is ours to experience?

Whatever we are waiting for—peace of mind, contentment, grace, the inner aware-ness of simple abundance—it will surely come to us, but only when we are ready to receive it with an open and grateful heart.

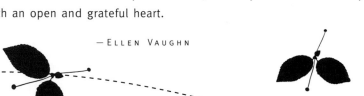

— ELLEN VAUGHN

When do you experience an open heart? What are the conditions that foster your willingness to open your heart? As we practice true gratitude, we learn to take the risk over and over again. That's because we understand that we are constantly receiving blessings and can trust that we will continue to do so. We are aware of what we are receiving and so don't take it for granted.

Our work-a-day lives are filled with opportunities to bless others. The power of a single glance or an encouraging smile must never be underestimated.

— G. RICHARD RIEGER

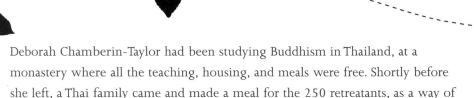

Deborah Chamberin-Taylor had been studying Buddhism in Thailand, at a monastery where all the teaching, housing, and meals were free. Shortly before she left, a Thai family came and made a meal for the 250 retreatants, as a way of expressing their gratitude for the teachings of Buddhism.

Shortly thereafter, Deborah was helping to plan a weekend retreat in Northern California. The planning group was discussing how to feed lunch to all those who would be attending, because the cost of lunch was not in the budget. Filled with a sense of gratitude for the generosity of the Thai family, Deborah found herself volunteering to pay for lunch for all the participants. "I noticed what joy it brought me to consider giving such a gift. . . . Later when I told this story to a group, I was pleasantly surprised when person after person walked up and handed me unsolicited money for the 'lunch fund.' They also wanted to be part of fueling the 'cycle of generosity.'"

As this woman's story shows, gratitude begets generosity, which begets gratitude, which begets generosity. It's a beautiful, never-ending cycle.

When I feel the joy of receiving a gift my heart nudges me to join creation's
ballet, the airy dance of giving and receiving, and getting and giving again.

— LEWIS SMEDES

Gratitude and generosity are like the in- and out-breath. Like the in-breath,
gratitude creates a sense of fullness; it is, in fact, the sense of fullness. And
from this fullness, we feel moved to give, like the exhale of the breath. That's
because true kindness and generosity come from a response to the sense of
fullness; we give best from overflow.

The more you feel grateful, the stronger is the impulse toward giving.
And the more you give, the more you get—love, friendship, a sense of purpose
and accomplishment, even, sometimes, material wealth.

It doesn't have to be an extravagant, expensive gift. When we live with a
grateful heart, we will see endless opportunities to give: a flower from the garden
to a coworker, a kind word to our child, a visit to an old person. You will know
what to do.

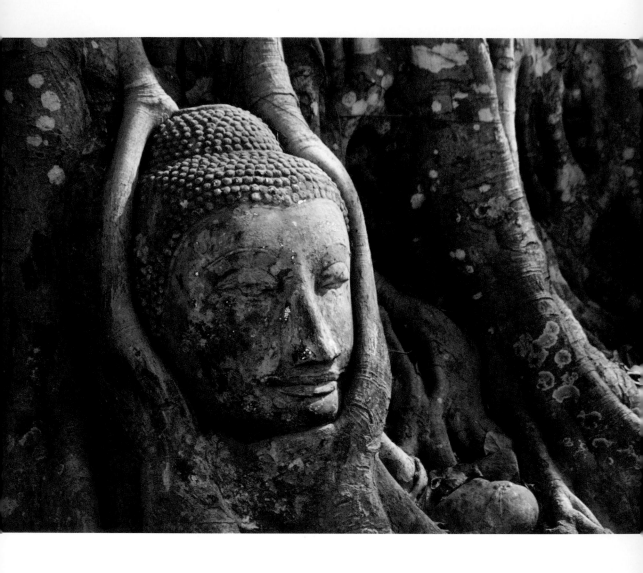

Let us rise up and be thankful, for if we didn't learn a lot today, at least we learned a little, and if we didn't learn a little, at least we didn't get sick, and if we got sick, at least we didn't die; so, let us all be thankful.

— BUDDHA

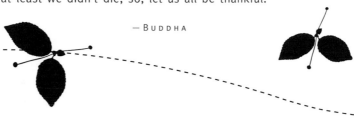

Bitterness is a poison that snuffs the light of our souls, hardening us to life's pleasures and joys by keeping us focused only on what is wrong. When the man I lived with for fourteen years left me, he said it was because I was turning bitter and he didn't want to stick around to see it. Although there were other reasons for our breakup, including many he was responsible for, after the pain of the loss had subsided, I gave thanks to him for the wake-up call; I *was* turning into a resentful woman, and that was the last thing on Earth I wanted to be.

I'm determined not to sink into bitterness. While there are plenty of things in life to be justifiably annoyed, angry, or hurt at, that doesn't mean that I should completely ignore all that is beautiful, good, and touching. I want my soul to shine with an overflowing of love, and practicing gratitude is one of the best ways I know to do it.

I feel this communion, this strange attunement, most readily with large white pines, a little less with sugar maples, beeches, or oaks. Clearly white pines and I are on the same wave-length. What I give back to the trees I cannot imagine. I hope they receive something, because trees are among my closest friends.

— ANNE LABASTILLE

In *The Continuum Concept*, Jean Liedloff describes a profound experience she had when she was eight years old. "The incident happened during a nature walk in the Maine woods where I was at summer camp. I was last in line; I had fallen back a bit and was hurrying to catch up when, through the trees, I saw a glade. It had a lush fir tree at the far side and a knoll in the center covered in bright, almost luminous green moss. The rays of the afternoon sun slanted against the blue-black green of the pine forest. The little roof of visible sky was perfectly blue. The whole picture had a completeness, an all-there quality of such dense power that it stopped me in my tracks. . . . Everything was in its place—the tree, the earth underneath, the rock, the moss. In autumn it would be right; in winter under the snow, it would be perfect in its wintriness. Spring would come again and miracle within miracle would unfold, each at its special pace, some things having died off, some sprouting in their first spring, but all of equal and utter rightness. . . .

"That night in my camp bed I brought The Glade to mind and was filled with a sense of thankfulness, and renewed my vow to preserve my vision."

How can you connect to nature today?

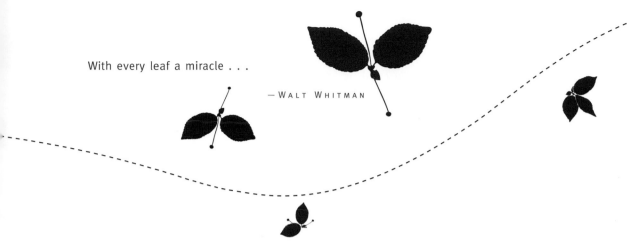

With every leaf a miracle . . .

— W A L T W H I T M A N

When we're in touch with a profound sense of gratitude, we connect to all of life, recognizing the miracle in the tallest tree, the smallest bug, even those parts of nature we might find slimy and repugnant, such as slugs and snails.

Such a sense of connection is purely joyful; it grants to our human endeavors no more or less importance than they should have, and inspires us to do whatever we can to conserve and protect all of the natural wonders of the Earth and sea, not just those that are convenient for us. Thus gratitude also gives birth to a fiercely loving environmentalism, a sensitivity born of the connection made explicit between us and everything else that creeps, crawls, sways, and clings. We recognize that we cannot live outside of the great web of life that lovingly holds us in its nurturing embrace, and we vow to protect the sanctity of that web.

If the only prayer you say in your whole life is "thank you," that would suffice.

— MEISTER ECKHART

However you experience God—as loving Father, nurturing Mother, Creator of all that is, your Higher Power, the Spirit of Kindness and Compassion, whatever is true for you—the quickest, easiest way to connect to Him/Her/It is to express your gratitude. That's because gratitude is the response to the giver of a gift—and when we give thanks for things beyond the gifts we receive from other people, we are de facto thanking the Greater Power for what we have received: food, shelter, the beautiful sunny day, life itself. As we give thanks, our spirits join with the Great Spirit in the dance of life that is the interplay between giver and receiver.

Saying thank you is more than good manners. It is good spirituality.

—ALFRED PAINTER

I love the sensibility that is inherent in Native American spirituality. Whenever a person is about to take the life of something—a deer, a tree—he or she humbly asks permission of the Spirit that dwells in the animal or plant, and gives thanks for their willingness to sacrifice their own life. Sometimes, an offering—a pinch of corn or tobacco—is given in compensation. Such an act acknowledges that something has been given and received on both sides.

No matter what we're doing, something is being offered and accepted. How can you and I be more aware of this exchange of giving and receiving moment to moment?

Nobody can conceive or imagine all the wonders there are unseen and unseeable in the world.

— FRANCIS P. CHURCH

Morihei Ueshiba, the father of Aikido, once described an experience he had walking alone in his garden. Suddenly "I felt that a golden spirit sprang up from the ground. . . . My mind and body turned into light. I was able to understand the whispering of the birds, and was clearly aware of the mind of God . . . the spirit of loving protection for all beings. Endless tears of joy streamed down my cheeks. Since that time, I have grown to feel that the whole earth is my house. . . ."

Have you ever had an experience in which you slip out of ordinary space and time and tap into the flow of the universe, where there is no separation between you and everything else and where everything seems perfectly right just as it is? Some people find such moments of transcendence through meditation, others in nature, still others when making love. As a young child, I often experienced such moments in the early spring tromping alone in the icy stream near my house.

Gratefulness primes the pump of such ecstatic experiences.

The essence of all beautiful art, all great art, is gratitude.

—FRIEDRICH NIETZSCHE

Moments of grace and beauty are rare gifts, in which we open to an expansive, ecstatic state of Big Mind, the place where all is right with us and the world. These moments of grace are so rare and so wonderful, that many spiritual seekers spend a lifetime trying to experience them. And the desire to feel such expansiveness is often the impetus for taking mind-altering drugs.

I'm convinced that you don't have to meditate for years on a mountaintop, or take LSD to experience such transcendence. All you have to do is tap into the fullness of a sense of gratitude, and grace will likely descend. (Indeed, I am sure that what meditation and mind-altering drugs do is break down the barriers to experiencing gratitude in its full abundance.)

We can't force or demand such magical mystical experiences. But we can offer ourselves up as willing and worthy participants by reveling in the wonders that we are already experiencing. Through gratitude, our souls, in Emily Dickinson's words, "always stand ajar; ready to welcome the ecstatic experience."

PART **2**

the grace of gratitude

The most powerful agent of growth and transformation is something much more basic than any technique: a change of heart.

— JOHN WELWOOD

Attitudes are the underpinnings of action; we can't change on the outside until and unless we transform our thinking, transform the way we imagine ourselves and our reality. The good news is that we really can decide to see the glass as half-full rather than half-empty, and that decision will have profoundly positive effects not only on our happiness and that of those around us, but on the way our whole lives unfold.

The Zen master Ling Chi said that the miracle is not to walk on burning charcoal or in the thin air or on the water; the miracle is just to walk on earth. You breathe in. You become aware of the fact that you are alive. You are still alive and you are walking on this beautiful planet. . . . The greatest of all miracles is to be alive.

—THICH NHAT HANH

Thich Nhat Hanh is a Vietnamese Buddhist monk who now lives in exile in France. While living in Vietnam, he endured all kinds of hardships, including the deaths at the hands of the French, Americans, and Vietnamese of his family members and friends. An orphanage that he started was bombed. And yet he is a walking example of joy and gratitude. When asked how he survived such difficulties with such peace and love in his heart, he replied that every morning he used to ask himself what he could count on that day; sometimes all it was was the blue sky and the brown earth, and the fact that he was still breathing in and out. But in counting his blessings, so to speak, he reconnected to the miracle that he was, at least for the present moment, still alive in this beautiful world. "Suffering is not enough. Life is both dreadful and wonderful," he reminds us. "How can I smile when I am filled with so much sorrow? It is natural—you need to smile to your sorrow because you are more than your sorrow."

That's what we're all called upon to do—to notice what we can appreciate right now, no matter what else is going on in our lives.

Learning to live in the present moment is part of the path of joy.

—SARAH BAN BREATHNACH

Buddhist and Sufi teachers spend a lot of time talking about "waking up," by which they mean, I think, living life to its fullest because we are aware of living it moment to moment. Aware of breathing in, aware of breathing out; aware of chewing and swallowing our food; aware of placing one foot in front of the other when walking. Aware of seeing your infant son, of the effect of your words on a coworker, of the fact that your one foot is resting on top of the other.

They all teach that waking up is a process, that it doesn't just happen once and for all, but rather, must occur again and again as we realize we have forgotten the miracle of being alive, and in recognizing our forgetfulness, we wake to the miracle once again. In the moments that we are awake to the wonder of simply being alive, gratitude flows, no matter our circumstances.

The hardest arithmetic to master is that which enables us to count our blessings.

— ERIC HOFFER

When times have been tough for me, before getting up in the morning, I have taken inspiration from Thich Nhat Hanh and asked myself what I could count on that day, both externally—like that I still had a place to live and food on the table—and internally—the deep love and trust, for example, that I feel for my friends.

It's a wonderful antidote to worry and an opener to gratitude, provided that you really stick to what you can count on today. Sometimes I would find myself, for example, when I thought about the fact that I had a house, saying, "Yes, but I don't know if I can afford it tomorrow and what if the earthquake strikes, and . . ." Then I would have to stop and say, "This is just for today. What can you count on today?" As we learn how to appreciate the miracle of being alive, we will find the peace and the strength to face life's challenges as they come.

Einstein was asked what he thought the most important question was that a human being needed to answer. His reply was "Is the universe friendly or not?"

—JOAN BORYSENKO

For most of my life, I have subscribed to the "Watch out—disaster might strike at any time, so don't get too complacent" school. It probably comes as no surprise that I have suffered from chronic muscle spasms in my back and neck my whole life—even my body is perpetually tensed for trouble. By age forty-four, I was just plain sick of it, tired of waiting for the boom to fall, tired of clenching in fear rather than opening in expectation. So I decided to live as if the universe were friendly.

I have been meditating on Einstein's question for over a year now, and I am convinced that how each of us answers it is the key to whether we are happy and joy-filled or not, and whether or not an attitude of gratitude comes easily. If we believe the universe is friendly, then we believe that life is on our side, that good things will come our way, and that even when bad things happen, they are bumps in the road designed to teach us to become more wise, more whole, more loving. In this view of the universe, gratitude flows from us naturally, as an instinctive response to the bounty we perceive all around us.

If, on the other hand, we believe the universe is unfriendly, then we see our life as an endless struggle against difficult odds, believe that bad things are either

random or sent purposely to torture us, that there is nothing we can count on and therefore must brace ourselves for the next crisis, hoarding what we have. In this view, gratitude is very situation-specific. We're grateful—maybe—when things go well, but we are always ready for the boom to fall and for it all to disappear.

I have lapses in believing in the friendly universe, particularly when things are going badly money-wise. When I forget, I take out a piece of paper on which I've copied down a piece of an Inuit teaching: "The inhabitant or soul of the universe is never seen; its voice alone is heard. All we know is that it has a gentle voice, like a woman, a voice so fine . . . that even children cannot become afraid. And what it says is '*Sila ersinarsinivdluge,*' 'Be not afraid of the universe.'" It helps me remember that if I place my trust in the beneficence of the universe, things tend to work out. And if they don't, at least in the meantime I will enjoy myself a whole lot more and be more fun to be around.

One's destination is never a place but rather a new way of looking at things.

—HENRY MILLER

We've probably all had someone in our lives tell us we should be grateful for something, or perhaps we say it to ourselves. Either way, it is the least likely way to promote an attitude of gratitude. Nothing destroys a sense of gratitude faster than being told we "should" feel grateful. While some "should's" are necessary when teaching manners to children (for children learn not only by example, but by pairing instruction to example), when we try to experience gratitude as a living force in our lives, guilt, whether imposed by others or by ourselves, is a deadly killer.

Guilt makes us want to run away from whatever is making us feel bad, and to avoid looking at whatever is underlying it. So I don't want you in reading this book to go away thinking you "should" feel grateful. I want to encourage us all to open our hearts and experience gratitude as much as we can. But I know for myself that there are days when it is impossible for me to feel thankful for *anything* no matter how hard I try—and if that's true for you sometimes, be gentle with yourself. The more you allow what is true for you to be true, and the less you "should" yourself, the more space you create for the possibility of gratitude to quietly, softly enter your heart.

61

To educate yourself for the feeling of gratitude means to take nothing for granted, but to always seek out and value the kind that will stand behind the action. Nothing that is done for you is a matter of course. Everything originates in a will for the good, which is directed at you. Train yourself never to put off the word or action for the expression of gratitude.

—ALBERT SCHWEITZER

As far as I can tell, gratitude is generated in two ways—one, by a spontaneous upswelling of the heart toward the wonder of life and all its particulars, and two, by a conscious decision to practice looking at what's right in our lives rather than focusing on what's missing.

You don't have to wait for the feeling to have the experience. Rather, by training yourself to count your blessings, you can experience the feeling in all its majesty. It's a discipline of the heart that will bring you greater joy and contentment every single day of your life.

Inside yourself or outside, you never have to change what you see, only the way you see it.

—THADDEUS GOLAS

I went to see my father in the hospital about a week before he died. He had suffered for years with emphysema, was now hooked up to an oxygen tank, barely able to move around, and was failing fast. Bedridden, he was on constant oxygen and medication; his six-foot-two frame weighed only 130 pounds because eating anything but ice cream was too difficult. Every breath was a labored struggle. I asked him whether the quality of his life was worth all the effort. "I still enjoy being alive," he responded. "Sometimes it's easier to breathe and then I really enjoy just quietly taking a breath. I still enjoy reading the comics in the newspaper and watching the ball games on TV. My life is good." He said not a word about all that he had lost, all that he would never do again.

My prayer is that each of us will have the grace to embrace the good in our lives, despite the suffering.

Gratitude is like a flashlight. If you go out in your yard at night and turn on a flashlight, you suddenly can see what's there. It was always there, but you couldn't see it in the dark.

— DAWNA MARKOVA

Gratitude is like a flashlight. It lights up what is already there. You don't necessarily have anything more or different, but suddenly you can actually see what is. And because you can see, you can't take it for granted. You're just standing in your yard, but suddenly you realize, Oh, there's the first flower of spring struggling to emerge from the snow; Oh, there's a deer emerging from the scrub brush; Oh, there's the measuring cup you've been looking for that your daughter was using to make mud pies. It's just your ordinary old backyard, but suddenly you are filled with happiness, thankfulness, and joy.

The great thing about the flashlight of gratitude is that we can use it day or night, no matter where we are or what our circumstances. It works whether we are young or old, fat or thin, rich or poor, sick or well. All we need to do is turn it on.

At times our own light goes out and is rekindled by a spark from another person. Each of us has cause to think with deep gratitude of those who have lighted the flame within us.

—ALBERT SCHWEITZER

What it takes to turn on the flashlight of gratitude varies from person to person. There was a renowned surgeon at a weeklong workshop who, when asked what surprised or inspired him that week, said, "Nothing." He was invested in being cynical. But something disturbed him—he knew he had "flunked" the test the workshop leader presented—and he was the kind of guy who always ended up at the head of the class. So he began to look around for things to report to the leader. By week's end, he was genuinely engaged in the excitement and wonder of life again. Even the other workshop participants noticed the difference.

No matter your circumstances, there is something you can acknowledge and appreciate about yourself or your life. Who has supported and loved you, even a tiny bit, at any point in your life, for instance? They saw your beauty and depth; can you be appreciative both for their presence in your life as well as for what they saw in you?

In relation to others, gratitude is good manners; in relation to ourselves, it is a habit of the heart and a spiritual discipline.

—DAPHNE ROSE KINGMA

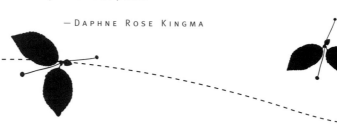

In my twenties and thirties, I learned a great deal about thankfulness from Daphne Rose Kingma. We spent a great deal of time together working on books, and over and over I would watch her make a personal connection to the people who came across her path—garbage collectors, long-distance operators, the person selling coffee on the corner. No matter what was going on in her own life, no matter how rushed or upset she was, she took the time to connect. I'd hear her on the phone with the airline reservations desk. In the course of getting a flight she'd learn the woman's name, where she lived, and the fact that she, like Daphne, loved flashy high heels. Daphne was so genuinely appreciative of the help that the other person felt washed in a warm bath of love. It was then I realized that while gratitude was a feeling, it could be cultivated—and set out to emulate her (although I still am not as good at it as she).

As we grow, one of our spiritual tasks is to cultivate positive emotions as "habits of the heart," as Daphne calls them. What this means is that we learn to love even when we don't "feel" loving, be kind when we'd rather be surly, and grateful when we don't particularly feel like being thankful. In this way, we turn feelings, which come and go, into conscious attitudes that we act upon even if we don't "feel" like it.

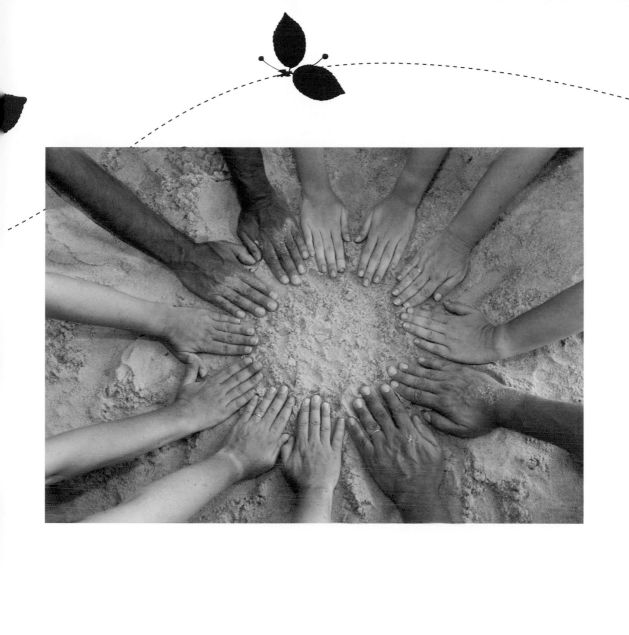

This is what binds all people and all creation together—the gratuity of the gift of being.

—MATTHEW FOX

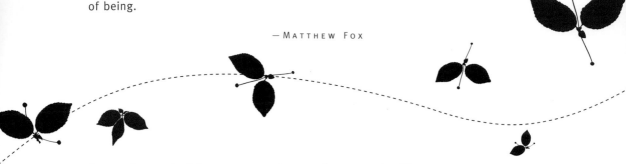

"My only son died five years ago; he was four and a half," writes a contributor to *Slowing Down in a Speeded Up World*. "One of the gifts his death brought was an excuse to stop the rush. For the first year, I allowed grief to wash over me whenever I needed to, and I let myself be open to the healing that surrounds us in this incredible world. I had time for a hug and to talk with my friends; I had vast amounts of time to cherish four and a half years of memories.

"Nowadays it isn't unusual for me to stop in my tracks when a rainbow arches over the bay outside my office window, or a tiny feather drifts down to me from the sky, or a child's laugh at McDonald's brings tears to my eyes.

"I realize how lucky I am, not to have lost my son but to have had him for as long as I did. I'm lucky to have known the importance of certain moments that catch your soul and may never come again."

Gratefulness, or "great fullness" as Brother David Steindl-Rast calls it, "is the full response of the human heart to the gratuitousness of all that is." He and Matthew Fox remind us that truly every single thing we have has been given to us, not necessarily because we deserve it, but gratuitously, for no known reason, and that the same is true for every living thing. We are connected one to another,

to sky and water and tree and snake, by virtue of being here together as part of the wheel of life. Whatever source we believe is the giver—some concept of God or the randomness of the Big Bang—the fact of our incarnation, the fact of the lizard's skin, the rose's scent, the blueness of the sky is an incredible gift. None of us—bee, flower, person—did anything to earn this gift, nor is anything required of us in return.

When, in a sudden moment—gazing at a field of daffodils, perhaps, or moving luxuriously through warm water, or listening to the painfully beautiful voice of Billie Holiday—we are struck by the truth of this amazingly free "no strings attached" gift, gratitude flows naturally from us, without effort. At such times, we don't need to work at feeling thankful; we just are.

In such transcendent moments, we take our place in the great wheel of life, recognizing our connection to one another and to all of creation. More than that, we actually become part of everything, so that we experience the truth that there is no separation between us and everything else—the sound, the sight, the feeling.

At such times, gratitude opens our hearts fully and we take in the love, the beauty, the joy that is ours to possess in every moment, in all circumstances. Through the gift of a grateful heart, we merge with the All and remember our rightful home.

It's the way we react to circumstances that determine our feelings.

— DALE CARNEGIE

One of the fascinating things about feelings is that they come and go, like waves in the ocean of our consciousness. Happiness, anger, fear, love, thankfulness—they arise in response to some external or internal trigger and then subside. We feel angry—and then we don't. We are "in love"—and then we aren't. We feel thankful—and then it's over. It's particularly easy to see the tide of feelings in a child, where they come and go so quickly and uncensoredly. One minute my daughter is screaming her head off because I have left the room. I return and pick her up—a big smile. Our attitudes are our mental stances, the positions we hold vis-à-vis life. In some ways, our attitudes determine everything, because they are the glasses through which we see the world. Is the world a wonderful place or a hellhole? All of us know that the answer to that question depends on our attitude on any given day. Has the world changed? Most likely our thinking about it has. When we consciously cultivate positive attitudes we begin to "remake" the world. We literally live in a different place because our attitudes about it have changed.

That's the irony about the relationship between attitudes and feelings. The more you cultivate the attitude, even if you don't feel it, the more you experience the feeling. The more loving we are, the more love we feel. The more joy we radiate, the more comes back our way. And the more thankful we are, the more we experience the richness of spirit that grateful feelings produce.

The secret to life is to know when enough is enough.

— DR. VINCENT RYAN

This was my father's favorite saying in his final years, and one of the last things he said to me before he died. I was contemplating selling my house and moving to a smaller one, and that was his pronouncement on the subject.

It was kind of ironic, since there he was, a family doctor for forty years, gasping and wheezing over the phone, barely able to speak, dying from smoking too much. But the fact that he learned the lesson late doesn't negate its truth. And it goes straight to the heart of the issue of gratitude—namely that gratitude makes us feel like we have enough, whereas ingratitude leaves us in a state of deprivation in which we are always looking for something else.

As we cultivate a true and deep appreciation for what we do have, we feel full and are therefore happy. That's why study after study shows that being happy has nothing to do with how much money we have (beyond subsistence). As Lao Tzu proclaimed, "He who knows enough is enough will always have enough."

We who lived in concentration camps can remember the men who walked through the huts comforting others, giving away their last piece of bread. They may have been few in number, but they offer sufficient proof that everything can be taken from a man but one thing: the last of the human freedoms—to choose one's attitude in any given set of circumstances. . . .

—VICTOR FRANKL

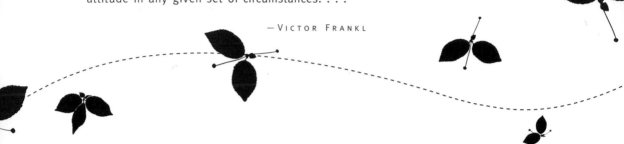

My friend Annette needs a kidney transplant. Everyone who knows her is amazed at her grateful attitude. Upon hearing the news, rather than adopting a "poor me" stance, she focused on the fact that while waiting for the transplant, she qualifies for a less invasive dialysis method. In telling me about the situation she proclaimed with a radiant face, "I am so thankful. I have four people who have volunteered to be tested to see if they can be a donor. Isn't that great! Four people are willing to give *me* a kidney."

I thought of Annette as I was driving the other day and saw a bumper sticker that proclaimed, "Attitude Is the Only Disability." While I am sure it was a slogan for disabled people's rights, I suddenly realized its larger implications—what we think about our lives—our attitude—has the ability to enable or disable us. As many spiritual teachers have said, we cannot necessarily change our circumstances. But we have complete control over what we think about our circumstances, the meaning we attach to them and what about them we choose

to focus on. No matter our circumstances—even, as Victor Frankl points out, in a situation as horrifying and potentially soul-killing as a concentration camp—we can focus on the positive and make a difference by virtue of our attitude.

Because of her attitude of gratitude, Annette may be "sick," but she is not disabled. Through gratitude, she is enhancing her ability to renew and recreate, which comes, as Joan Borysenko puts it, "when we lift ourselves out of the familiar axis and see life from a higher perspective." She is attracting all kinds of people who want to help—everyone from kidney donors and energy healers to coworkers offering to give her their comp time and folks volunteering to cook and clean for her while she's recuperating. We all want to be around her because she is such a teacher of gratitude and joyfulness.

Like no one else, she has proven to me that gratitude is an attitude that can be consciously chosen, no matter what our circumstances. We can focus on the negative—and descend into a spiral of negativity and gloom. Or we can choose to look at what's right in any given situation—and become a beacon of love and joy.

Gratitude has to do with feeling full, complete, adequate—we have everything we need and deserve; we approach the world with a sense of value.

As many people have pointed out, our consumer society owes its very existence to its ability to fuel a sense of never being satisfied. If we were happy about the way we looked, for example, why would we spend billions on cosmetics and plastic surgery? Or on expensive cars that supposedly convey a certain image that we don't have? Or the latest technological device? Caught up in lack, we feed the need but never feel truly satisfied because of course our substance of choice can't fill the lack. Consequently we continue to want more, more, more.

That's why the idea of cultivating "the gratitude attitude" is so popular among twelve-step programs. Addictions of all sorts come from a sense of deprivation, a feeling of lack that the user believes can be filled with a substance—alcohol, drugs, shopping, sex, food.

An attitude of gratitude gets us off the treadmill and out of the rat race of consumer society and addiction. We recognize that our sense of lack is, for the most part, an illusion. No matter our material circumstances, the richness of our soul is ultimately what brings us happiness, not another martini, bigger breasts, or the latest video game. At bottom our true needs are quite small. And the more we recognize what we do have, the less we'll need more.

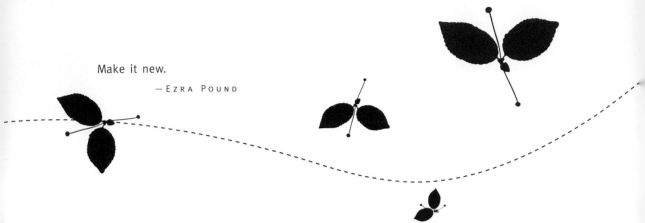

Make it new.

—EZRA POUND

I once went to a conference on relationships. Most of the presenters were therapists, who had all kinds of elaborate theories about what made good relationships. Then a Buddhist lama got up and said, "I know the secret to keeping love alive. It's simple. All you have to do is act as if you have just met this person and are falling in love. When you meet someone you are interested in, everything they do is wonderful. You love looking at them, hearing what they have to say. Even when they play you country western music, which you hate, you think, 'Well, maybe Tammy Wynette isn't so bad after all.' As time goes on, however, you take the person for granted and fight over Tammy Wynette. So the solution is to see your loved one new again." The therapists were up in arms, proclaiming that such a task was too hard. "Oh," said the lama, "I said it was simple. I didn't say it was easy."

I believe the lama is right. The secret to love—and a sense of joy and gratitude toward all of life—is to see, feel, and hear as if for the First Time. Before the scales of the habitual clouded the brilliant blue sky outside your office window, the tangy juiciness of an orange, or the softness of your loved one's hands. Before you got so used to her kind words, his musical laughter, that they became invisible.

There are two ways to live your life. One is as though nothing is a miracle. The other is as though everything is a miracle.

—ALBERT EINSTEIN

Someone once told me that evolutionary biologist Jared Diamond wrote *Guns, Germs, and Steel*, in answer to an aborigine's question, "Why do you guys have all the stuff?" Diamond set out to understand the historical reasons why, but the moral and spiritual issue is what haunts me.

Why *do* we in the West have so much of the stuff? We didn't do anything necessarily to deserve it (and those who think they did find themselves on a moral slippery slope, the end result of which assumes that those who are suffering from poverty, illness, or plagues did something to deserve *that*). Yes, we may have worked hard to get what we have, but at birth, we just woke up in our lives and found ourselves here in easier material circumstances than the vast majority of people in the world. Perhaps one of the reasons so many of us in this culture find it hard to experience an attitude of gratitude is that subconsciously we feel guilty for having so much when others have so little, so we want to ignore the truth of our good fortune.

I remember the first time I realized this personally. I was about twelve and writing an essay for Sunday school. I can't remember the question I was supposed

to be answering, but I ended up writing about how lucky I was to be living in the affluent United States instead of on the streets of India.

I don't know about you, but that childish realization now makes me pretty uncomfortable. First, it smacks of cultural imperialism; after all, who am I to say that my life is truly better? Just because we in the West have more stuff doesn't mean we are necessarily happier.

On another level, it makes me feel that I must do something important to continue to deserve my good fortune, and nothing can be important enough. At yet another level, it makes me want to ignore and deny my good fortune so that I don't have to feel guilty.

The issues are complex, and ultimately every person born into relative affluence has to define for themselves what their responsibility is. Here, I simply want to ask the question: Is it possible for us in this culture to truly and fully appreciate what we have been given without feeling guilty? If not, perhaps it is our responsibility to acknowledge our guilt, so that it doesn't block our willingness to be grateful.

I will not allow yesterday's success to lull me into today's complacency. . . .

— OG MANDINO

Recently my husband Don had vividly brought home to him how easy it is to get blinded to the miracles around us. When we first adopted our daughter Ana, we couldn't sleep; we were too busy looking into her peaceful face and crying tears of gratitude. A mere four months later, Don, who is home all day with her, finds himself taking her presence for granted, already losing that overwhelming sense of appreciation for her being sent to us. "I get bored," he says, "because it is so much the same, day after day. But her spirit, her presence, is no less a miracle today than it was four months ago, or will be four—or forty—years from now. And when I can remember that, I catch myself 'falling asleep' to the miracle, and the awareness wakes me again and my heart once again fills with joy."

When we can live our lives as if it is always the first time—the first time we made love, the first time we gazed upon the face of our beloved, the first time we tasted ice cream, the first time we saw a bird—we won't have to try to experience a sense of gratitude. It will be there, automatically, as a natural response to the beauty and the bounty.

84

You are a child of the universe, no less than the trees and the stars; you have a
right to be here.

— DESIDERATA

My stepdaughter invited a college friend to our house for a week during winter
vacation. I did the usual things hosts do for guests—put out clean sheets and
towels, made a bouquet of fresh flowers for the bedside table, found out what she
liked and didn't like for meals. I stocked up on bagels and made no food with
onions. At dinner, I made polite conversation, inquiring about her interests, her
family, her hopes and dreams. At the end of the week, she left, giving no indica-
tion of thanks in either word or deed. No note, no present, no phone call.

Now, I didn't entertain her to be thanked, and I wasn't even upset. Rather,
I was fascinated about where such a lack of gratitude came from. In talking to
my stepdaughter about it, she revealed that she has a hard time with this friend
because her friend has such a low sense of self-esteem. "I spent half my day reas-
suring her that she looks OK, that she said the right thing, that she is smart and
interesting," my stepdaughter complained.

Suddenly I got it—this young woman thinks so poorly of herself that it
doesn't even register that other people find her worthy of flowers and good
dinners. What I did was invisible to her because she is invisible to herself!
You deserve to receive all that you have been given. When you realize that,
you become more aware of just how much that is.

Low self-esteem is like driving through life with your hand-brake on.

— MAXWELL MALTZ

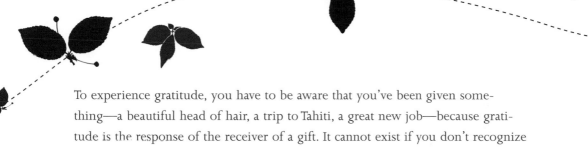

To experience gratitude, you have to be aware that you've been given something—a beautiful head of hair, a trip to Tahiti, a great new job—because gratitude is the response of the receiver of a gift. It cannot exist if you don't recognize that you have received a gift, and it can't exist if you don't feel worthy of getting the gift. A lack of self-esteem robs you of the joys of gratitude, because you have nowhere to put all that is being given.

By virtue of simply being alive, we receive gifts all the time—if only a new day, a second (or one thousandth) chance—and we are also worthy simply by virtue of being alive. If you have trouble seeing the gifts in your life, perhaps your self concept needs strengthening.

Take some inspiration from Maya Angelou. In a interview with Oprah Winfrey, she was once asked why, despite the hardships she faced, she never doubted herself. Her answer was that she came to realize that God loved her, and from that point on, she no longer had doubts. Because if God loves her, how can she doubt herself? Take that one on.

It is up to you to illumine the earth.

—PHILIPPE VENSIER

Tom Chappell, along with his wife, is the owner of Thom's of Maine, the natural personal care products company. In his audiotape, *The Soul of Business*, he describes how, despite his incredible material success—a big house, a huge boat, a very successful business—he woke up one day at age forty-three and realized that he felt disconnected from the company and himself. He considered retiring. Then he decided to go to divinity school to become a minister. There he refound his purpose, coming to see that his ministry was to incorporate into the business practices of Thom's of Maine the values that he believed in deeply and to help other businesspeople bring soulfulness into their workplaces as well.

If you want the habit of gratitude to grace your life, it is essential that you, like Tom Chappell, develop the belief that you are here on Earth to fulfill some purpose that only you can offer to the world. You are an amazingly rare, totally non-replicable individual with talents and gifts that the world anxiously needs. The more that you experience the truth of your uniqueness and beauty, the more you will feel gratitude for your particular gifts, and the more you will be able to deliver those gifts.

The deepest craving of human nature is the need to be appreciated.

—WILLIAM JAMES

Not many of us were born to parents who nurtured our individuality, honored our gifts, or helped us recognize our purpose. So as adults we may find it difficult to love ourselves in a wholehearted way that fosters a deep and quiet sense of self-appreciation. In *The Woman's Book of Spirit*, Sue Patton Thoele offers the following meditation: "It may help to realize the value of gratitude toward ourselves if we were to visualize our heart as a delicate treasure, hand-blown from the rarest ethereal glass. A treasure valuable beyond imagining—fragile, irreplaceable, price-less, and ancient. There is *no* other like it—infinitely precious, existing before time and after infinity.

"In reality, we *were* entrusted with such an inexplicable treasure when we were given the gift of life. We, and our wonderful hearts, are infinitely strong, vastly vulnerable, deserving and needing the gentle touch of gratitude and love.

"With your eyes closed, very gently put your hands over your heart and allow your breath to tenderly flow in and out of it. When you feel ready, ask to be given a symbol for your heart. Hold that symbol that you see or sense as carefully as you would a priceless Faberge egg. Beholding the wonder of your symbol, allow gratitude to flow through you, permeating the very cells of your being. Make a commitment with yourself to cherish and appreciate your heart-self."

89

People are always blaming their circumstances for what they are. I don't believe in circumstances. The people who get on in this world are the people who get up and look for the circumstances they want and if they can't find them, make them.

— GEORGE BERNARD SHAW

Is there something in your life that you find terribly annoying or difficult? Is there some hidden gift in the annoying situation that you can focus on to create an opportunity for gratitude?

For me it's standing in line. I absolutely hate to "waste" time—I live my life at a frenetic pace and don't want anything to get in my way of doing all I have to get done in a day. Until recently, I was the person in the line huffing and rolling my eyes at the wait, jiggling and looking at my watch every few seconds. And when I finally made it to the counter, I was too aggravated from having to wait to be pleasant to the person on the other side. But since life is full of lines, I finally decided to change my approach. Instead of being annoyed, I decided to see a line as a wonderful opportunity to slow down—to take a few conscious breaths, become aware of my body, and release as much muscle tension as I could. Now the waits are as long as ever—but I am grateful for the chance to stop.

We can spend a whole lifetime enjoying various benefits and not appreciate their value until we are deprived of them. How many lovers boldly contemplate separation, fondly imagining that they have had enough of the beloved. And yet as soon as they actually experience separation, they burn up with longing.

—JAMI

Boy, do I recognize myself in Sufi Jami's quote! Retroactive gratitude, I call it— realizing after something is over or someone is gone that I really appreciated what I had, but wasn't aware of it until it was gone. Good health, the smile of a loved one, a job that allowed for creativity and self-expression—the list of what we might have taken for granted is endless.

Failing to appreciate what we had until it's "too late" leads to regret, one of the most insidious negative feelings there is. Regret is a poison that keeps us in the past: If only I had told him more often I was thankful for all he gave me maybe he would not have left me; if only I had been more appreciative of my legs before I got hit by the car; if only I had told her how much her kind words meant to me; . . . if only, if only. Our minds spin around, creating story upon story of how life could have been better if we had taken less for granted.

Whenever I find myself swirling around in a fog of retroactive gratitude, I do two things. First, I take time to consciously thank the person or thing I have belatedly discovered my gratitude for. If the person is alive, I thank them via letter or phone call. If not, I send a mental thanks, as I do for a situation I am grateful for. Second, I take a hard look at my current life, at the things I might be taking for granted right now. By doing so, I won't have to live any longer with regret.

If this is true for you as well, let the fact of your regret send you into the world with ever more appreciation for the gifts you've been given.

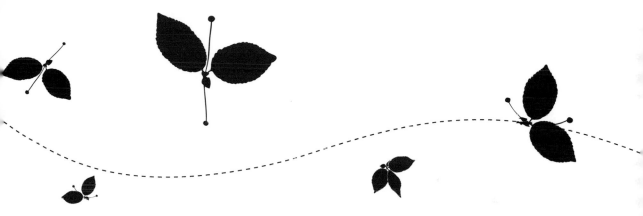

Appreciation can make a day, even change a life. Your willingness to put it into words is all that is necessary.

— MARGARET COUSINS

We can never know if being appreciative of someone else would have created a different outcome in our lives—maybe he wouldn't have left if you had nagged less and been grateful more, but then again, maybe not. What is for sure is that the more we give thanks now for the people in our lives, the fewer regrets we will have in the future, no matter what happens. Maybe you can't tell your sister who just died how grateful you were for her presence in your life, but right now you can tell your husband, your child, your best friend what they mean to you.

It's so easy to take the ones we love for granted. Let's all make a commitment to communicate that appreciation as often as possible.

It was then I learned that gratitude is the best feeling I would ever have, the ultimate joy of living. It was better than sex, better than winning the lottery, better than watching your daughter graduate from college, better and deeper than any other feeling; it is perhaps the genesis of all other really good feelings in the human repertoire.

—LEWIS SMEDES, AFTER ALMOST DYING

In *A Pretty Good Person*, Lewis Smedes, a professor of theology and ethics at Fuller Theological Seminary, tells the story of collapsing in his Minnesota apartment on a "frightfully cold December morning. . . .

"My lungs, it turned out, had been spattered by a buckshot of blood clots; and for a couple of days at the hospital I tilted in death's direction. On the fourth day a benign Norwegian physician by the name of Hans Engman leaned over my bed and congratulated me on surviving the twenty-to-one odds that medical statistics had stacked up against me. . . .

"A couple of nights later—in the moody hush that settles on a hospital room at two o'clock in the morning, alone, with no drugs in me to set me up for it—I was seized with a frenzy of gratitude. . . . I blessed the Lord above for the almost unbearable goodness of being alive on this good earth in this good body at this present time."

In doing research for this book, it was amazing to me how many people related the same story—that it took a brush with death to awaken them to a sense of gratitude. Over and over, I read about how car accidents, cancer experiences, boating mishaps, and other life-threatening difficulties were wake-up calls to live with more thankfulness for the ordinary things of life. These weren't intellectual decisions; rather, each person was overwhelmed with a tremendous feeling of gratitude, as Lewis Smedes describes, and from that feeling, made a pledge to cultivate gratefulness on a daily basis.

My question is this: Do *you* need to almost die to experience the joy available in this moment? Or is it possible, right now, to tap into the amazingly wonderful fact that you are alive, breathing in and breathing out, able to take in the world through your senses, able to smile to a stranger, caress a loved one, touch the soft down of a baby's cheek? We do not need to almost die to feel the wonderful warm bath of gratitude. In any moment, we can experience the world as new again, and touch the joyful ecstasy those who have gone through near-death experiences relate.

Think for a moment of something you almost lost but didn't—a friend in an argument, your car that was stolen but then abandoned, a breast, your life. Does your heart naturally swell in thanksgiving for their continued presence in your life?

Don't pray when it rains if you don't pray when the sun shines.

—SATCHEL PAIGE

"My Russian grandmother was my greatest teacher in gratitude," a coworker recently told me. "We were very poor, and I often would complain about not having this or that. Any time we went anywhere, she would use whatever happened as a lesson in giving thanks. We'd walk down the streets of New York and see a man without legs begging for food, and she would say, 'Now you send up a prayer right now to God thanking him for your legs and for the food in your belly.' She wouldn't do it to feel superior to the man, or to make me feel guilty, but to teach me that around us every day are ways to remind ourselves of the bounty we have, no matter what our circumstances, and the more we give thanks, the more likely it is that the blessings will continue. For years in my adolescence, I rejected her teaching. But lately I've begun to notice that the more I give thanks, the better my life goes. When I become ungrateful, things tend to fall apart."

A lot of the recent writing on gratitude makes it sound like some kind of insurance policy—that the reason to feel grateful is to make sure that good things will continue to come our way. That feels spiritually materialistic to me, like praying for a pink Cadillac or a mink stole. True gratitude is a natural response to the miracle of life as we experience it moment to moment, a sense of abundance from the heart that is independent of our desires for the future.

As I express my gratitude, I become more deeply aware of it. And the greater my awareness, the greater my need to express it. What happens here is a spiraling ascent, a process of growth in ever expanding circles around a steady center.

— BROTHER DAVID STEINDL-RAST

Have you ever noticed that if you learn a new word you suddenly hear it everywhere? Or your friend introduces you to blue lobelia, and you suddenly notice its blooming all over?

Exactly why this happens is somewhat of a mystery, but I believe it's because everything is around us *all the time*. We are choosing, mostly unconsciously, to notice certain things and not others because we just cannot pay attention to everything. As we change what we pay attention to, we notice *that* more. Scientists have proposed that something more amazing is at work—that reality is open to the mind's causal influence and is, in the words of David L. Cooperider, "often profoundly created through our anticipatory images, values, plans, intentions, beliefs and the like." Meaning we actually participate in creating what happens to us by the power of our positive or negative imagery.

In either case, the more we are grateful, the more we will have to be grateful for. Even if nothing more or better happens, our eyes are opened to the gifts that were always there. As Susan Jeffers notes, "When we focus on abundance, our life feels abundant; when we focus on lack, our life feels lacking. It is purely a matter of focus."

If you haven't got all the things you want, be grateful for the things you don't have that you don't want.

— ANONYMOUS

Sometimes we are in such a negative state that the only way we can connect to a sense of gratefulness is to count all the bad things that aren't happening to us: *Well, the dog didn't get hit by a car today; I don't have Alzheimer's yet; my kid didn't pierce her nose today; an earthquake didn't strike.*

Counting blessings that are blessings by virtue of their not having struck, the more outrageous the better, is a great mood elevator. By the time you recite your list to a loved one or friend, you should be feeling a whole lot better.

But it has a serious aspect to it as well. When you really think about it, *isn't* it wonderful that the tornado didn't strike? Isn't it *great* that the house didn't burn down? (It's all too true a possibility. Four of my closest friends have had their homes or businesses burn to the ground.) Sometimes we need to look at what hasn't befallen us to wake ourselves up to the joys of our ordinary life.

Often we arrive at this place by hearing about the misfortunes of others— "Oh, thank God it wasn't my child in that car crash"; "I'm so grateful that it's not my husband who's losing his job"; "Think of all those poor people who lost their homes." Such reactions are human nature, I suppose, and yet it would be wonderful

if we didn't need the sorrows of other people to remind us of the blessings in our own lives. Rather, if we consciously count our blessings on a daily basis, including those that are blessings by virtue of their not happening, instead of experiencing a sense of grateful relief when we hear about someone else's misfortune, perhaps we will be spurred into the action that comes from an awakened sense of compassion.

PART **3**

the acts of gratitude

Beginning to tune into even the minutest feelings of . . . gratitude softens us. . . .
If we begin to acknowledge these moments and cherish them . . . then no matter
how fleeting and tiny this good heart may seem, it will gradually, at its own
speed, expand.

— PEMA CHODRON

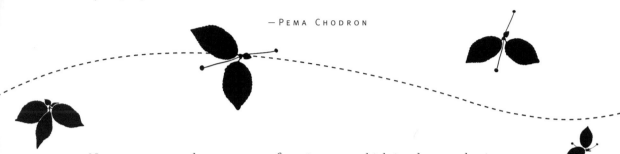

Now we come to the next stage of our journey, which is where we begin to put
our attitudes into action. Here we don't just feel grateful, but we move to express
our feelings of gratefulness in a variety of ways that enrich our lives and the lives
of those around us. This is where we truly ripen as souls, for it is easy to pay lip
service to the idea of gratitude and not take the final step of *embodying* it. But
when we begin to practice gratitude, we create a powerful resonance between our
thoughts and our actions, and our souls shine forth in all their brillance.

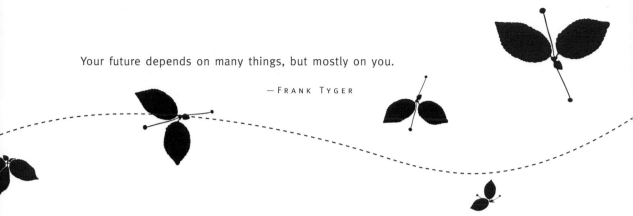

Your future depends on many things, but mostly on you.

—FRANK TYGER

Developing the muscle of gratitude is just like exercising any other. At first it will seem weird, awkward, perhaps even hard to do. But if you keep at it every day, soon you won't even have to think about it. Whether you keep a gratitude journal or start a practice of thinking about all you are grateful for as you drive to or from work, creating some daily ritual really helps build the muscle. Only you know what will work best for you—a file on your computer, a beautiful blank book, an audiotape in your car. Whichever format you pick, make a commitment to list ten things every day that you are grateful for. Pretty soon it will be second nature. Here's the beginning of my list: "I didn't get in a car accident; my computer worked; my baby is healthy; it stopped raining; I had steak for dinner; my house is warm and dry; my sister called. . . ."

As you wander on through life, sister/brother, whatever be your goal, keep your eye upon the donut, and not upon the hole.

— SIGN IN THE MAYFLOWER COFFEE SHOP, CHICAGO

Best-selling author Iyanla Vanzant, who penned such inspirational books as *Acts of Faith* and *One Day My Soul Just Opened*, has lived the prototypical rags to riches story. A former welfare recipient, she was about forty when her life began to turn around. Through it all, she claims, her sense of gratitude kept her going. "I'm grateful for everything," she says, "from being homeless to sitting in a half-million dollar house."

This remarkable woman is pointing to something very important about gratitude—that we can experience it even "in spite of" something else—that our friend is lying in a hospital dying, that millions of people are starving as you read this book, that our own lives have trials and tribulations that might be sorely testing us.

We can't wait until everything is OK—with us or with the rest of the world—to feel thankful, or we will never experience it at all. "The world is too bent for unshadowed joy," Lewis Smedes points out, and so we must catch and kiss our joy as it flies by, even in the midst of sorrow or suffering. This is not to imply that we deny our suffering, but just that we not allow our suffering to blind us to the beauty and joy that surrounds us no matter what else is going on. It's a matter of where you choose to put your attention.

Normal day, let me be aware of the treasure you are. Let me learn from you, love you, bless you before you depart. Let me not pass you by in quest of some rare and perfect tomorrow. Let me hold you while I may, for it may not always be so. One day I shall dig my nails into the earth, or bury my face in the pillow, or stretch myself taut, or raise my hands to the sky and want, more than all the world, your return.

— MARY JEAN IRON

It's hard to appreciate the ordinary, except in contrast to something hard or challenging. I am always reminded of the truth of this when I've been sick. When I am well, I take my physical being for granted. I don't particularly notice how I feel—I'm simply not aware of it. But when I've been sick and begin to feel better, I am filled with immense gratitude for how good it feels not to be sick— not to have an aching head, a burning throat, leaden muscles and joints. I feel exactly as I normally do, but now I notice how great that is. Other people experience this sensation from a close call in a car or plane, an almost-bankruptcy— anything that shakes us out of complacency and wakes us to the wonder of our ordinary existence.

The trick, of course, is to learn how to have that awareness without having to be sick, almost lose your house, or get smashed in a car crash. One way to do it is to pick an ordinary task, something you do every day, and decide that just for

today, you will do it with awareness. It can be anything—washing dishes, chopping vegetables, making the bed. Instead of doing it thinking about something else—the dinner that still needs to be made, how mad you are at the driver who cut you off—you actually pay attention to the task itself rather than being on automatic pilot. You notice the high-pitched whirring of the vacuum cleaner, the hard-yet-soft feel of the ribbed hose in your hand, the sight of the white dog hairs against the hardwood floor as they are sucked into the vacuum. . . .

This kind of awareness practice, the more specific the better, is great for fostering a sense of appreciation for the ordinary. As Rick Field notes, "When we pay attention, whatever we are doing—whether it be cooking, cleaning or making love—is transformed. . . . We begin to notice details and textures that we never noticed before; everyday life becomes clearer, sharper, and at the same time more spacious." Our eyes are opened once again to the miracles of the absolutely ordinary and joy fills our hearts.

The grand essentials to happiness in this life are something to do, something to love, and something to hope for.

—JOSEPH ADDISON

A friend of mine who has health problems recently decided to sell her big, beautiful house in the country and move to a small condo in the city. But she's been finding it quite difficult to let go of all the beautiful attributes of her big house, particularly since she's discovered that her budget won't allow for certain amenities she was counting on. "Yesterday," she confided to me, "I found out that I can't have the French doors I had my heart set on. I started to feel terrible, but then I asked myself, honestly, do you *need* French doors? The answer of course was No, and I felt much better."

When we focus on what we truly need, as opposed to what we might like or want, life gets much simpler, and it's much easier to feel grateful. Because, when it comes right down to it, there's not a whole lot that we really need. Do we *need* a cherry red Jeep? A trip to Barbados? What about a television? A garden? Time off with family? A job that gives you a sense of purpose? If you really think about it, it's not a long list: food, shelter, rest, loved ones, something meaningful to do. That's about it. All the rest of the stuff of life are wants.

Now, every time I get caught up in wanting something and bemoaning the fact that I can't have it, I ask myself, "But do I *need* this to be happy?" It's amazing how often the answer is No.

There are many ways to victimize people. One way is to convince them that they are victims.

— KAREN HWANG

Nothing blocks feelings of gratitude more than anger and resentment. That's why the practice of gratitude requires the work of forgiveness. We can't feel grateful to our parents for what we received from them when we are still angry about their abuse, self-involvement, sensitivity, alcoholism, or neglect. Nor can we receive the gifts of a relationship that has ended when we still feel hurt over betrayal, angry over deceit, sorrowful over abandonment. Nor should we. Trying to force ourselves to feel grateful when such strong negative feelings exist only compounds the injury. We have been hurt. Let's not deny our woundedness on top of everything else. Healing, in the form of acknowledging the grievance and grieving the loss or wound, needs to happen first.

However, there comes a time in the process of emotional resolution for forgiveness. For only forgiveness can move us out of the victim stance and free us to move on. Depending on the kind of wound you have suffered, this may be deep psychological and spiritual work. No one can talk you into it. No one can do it for you. Only you can come to the place where you want to forgive.

Forgiveness leads to gratitude, and not just gratitude in general, but in a beautifully healing movement, to an outpouring of appreciation for the very things that caused such pain in the first place. Thus is our suffering redeemed.

Oh, for the wonder that bubbles into my soul.

— D. H. LAWRENCE

Recently I took my one-year-old daughter to the zoo for the first time. Her eyes almost popped out of her head when she saw an elephant. And when I gave her her first scoop of ice cream, her joy knew no bounds. Her little body wriggled, her eyes sparkled, and she brought out the biggest smile. The truth is elephants *are* amazing creatures, and ice cream is just as delicious the one thousandth time as the first. But we adults have lost our wonderment, and so we don't appreciate elephants and ice cream as much.

We can recapture our sense of wonderment at any moment. All it takes is to open our senses and let the world come into us anew. Try it for one minute. First, listen to the sounds around you: Perhaps an airplane is overhead. Isn't amazing that airplanes can fly? It doesn't seem possible. What kinds of scents are in the air? I can smell jasmine. Isn't it amazing that so many flowers have such distinctive scents?

Now turn to your sense of sight. Really notice what's around you: the grain in the wooden door; the black letters against the white page, the bright yellow

bananas in the bowl. Isn't it amazing that you can see? Isn't it fascinating to wonder if everyone can see yellow the same way as you? Isn't it marvelous that you can have a banana even though they grow thousands of miles away? We can touch wonder in every moment as we slow down and perceive the world around us as if for the first time. And when we contact wonder, we know thankfulness for the most ordinary, extraordinary things of life.

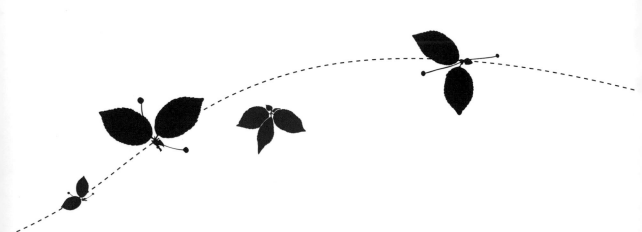

Life begets life. Energy creates energy. It is by spending oneself that one becomes rich.

—SARAH BERNHARDT

Driving home the other day, I heard on the radio that as the stock market has risen, so have the salaries of corporate bosses that take stock options as part of their compensation. This year, the head of Disney made $10 million, another guy in L.A. made $45 million, and that's not even considering Bill Gates. I could feel my blood turning green with envy, and all sense of gratitude for my own life—that I have a wonderful, loving family, close friends, a beautiful house, fundamentally good health—went flying out the window. "If only I could have just *one* of their many millions," I thought, "then my life would be happy."

The truth is, of course, that happiness is an inside job, and beyond the subsistence level, money truly has very little to do with our happiness. But most of us are convinced that money can indeed buy happiness. The universality of that feeling struck me a few years ago when I read about a study that asked people how much money they thought they needed to be happy. Everyone, no matter what they made, thought they needed more. People who made $20,000 thought $30,000 would do it; folks at $45,000 were convinced $65,000 was the magic number, people at $100,000 were sure $200,000 was it. The only thing that

changed was that as people's incomes grew, their magic number grew exponentially (proving like nothing else that the "gimme hole" only grows through feeding). I realized then that there is something in human nature—well, at least in contemporary Western human nature—that will always long for more and envy those who have it, and the only way to deal with that trait is to acknowledge it— Oh, there you are again—and turn our attention back to what matters.

Here's a practice for dealing with envy. Spend one day with one pocket of change and one empty pocket. Each time you find yourself envious of someone, put a coin in the empty pocket and ask yourself, "What is there that I am noticing in the other person that I want to find in myself?" (Because you wouldn't notice it if it weren't already in you.) If it's money, is it the freedom? The chance to play that money buys? A sense of security? Whatever it is—more play, a sense of security, free time—you can work on getting more of it in your life, no matter the circumstances.

I can choose to spend my time envying Bill Gates, the housewife who doesn't have to work because her wealthy lawyer husband provides for all her needs, and the person down the street who just inherited a large estate from his mother, or I can begin to understand what I am really longing for in myself.

I use envy as a trigger to remember that I want to do a better job of giving myself away, so that I will experience a true sense of richness, no matter what my material resources. I can't keep the green-eyed monster from rearing its ugly head from time to time, but I can use its appearance to rededicate myself to using myself fully on behalf of the world as a whole. The feeling of abundance—great fullness—that doing the work our soul is here to do is better than any old million dollars.

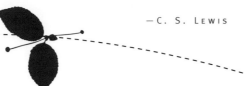

It seems to me that we often, almost sulkily, reject the good that God offers us because, at the moment, we expected some other good.

— C. S. Lewis

The most ungrateful person I know is a woman who can't see the beauty of her life because she is so bitter that it didn't turn out the way she thought it should. She has a lovely home and garden, healthy, bright, successful children, a fifty-year marriage, and the means and health to travel. No one in her immediate family has died or been seriously ill; she's never known poverty or lack; she is, from all external measures, highly privileged, with much to be grateful for. And yet all of what she has is completely invisible to her because it somehow doesn't match her expectation. Her kids don't live close enough or visit often enough; she wishes there were even more money; her marriage isn't as loving as she desires.

Expectations are the killers of gratitude and joy: If you expect to live in the Taj Mahal, your cozy little cottage will feel pretty awful; if you expect your son to become a doctor, you can't appreciate him for the fine body worker that he is; if you focus on how you are going to be miserable without a BMW, your trusty rusty Toyota that reliably gets you around will only bring you misery.

Having hopes, dreams, and visions for the future are one thing. But we need to be careful that such envisioning doesn't get in the way of our appreciating the things we do have in the here and now. Let's not miss the beauty of our actual lives while we're lusting after a mythical perfect life.

Gratitude is the memory of the heart; therefore forget not to say often, I have all I ever enjoyed.

—LYDIA CHILD

Sometimes life is so challenging, so painful, that it is plain impossible to feel grateful for anything that is going on. At such moments, it's nice to have a reservoir of contentment to fall back on, a storehouse of joyful memories to open and hold onto as you navigate through the dark night of the soul.

A good memory doesn't just work for really tough times. It also helps to smooth over the little bumps and glitches of ordinary life, particularly in relationships. When I find myself annoyed with something my husband is saying, for instance, if I can remember the piece of angel food cake he brought me as a surprise yesterday while I was working, my annoyance melts as my gratitude is engaged. A good memory also helps, for example, when you find yourself angry at a coworker for failing to meet a deadline. Recalling with gratitude how often she has come through for you in the past, you graciously let her off the hook.

A good memory keeps us from losing our perspective, from being so caught up in the work of the here and now that we forget the larger bounty of our lives. I'm not suggesting that we should deny our suffering or ignore the problems in our lives, just that we can balance them with joy and peacefulness by remembering moments, events, people, that we are grateful for.

It's good to have an end to journey toward; but it's the journey that matters, in the end.

—Ursula K. LeGuin

The practice of gratitude requires that you slow down long enough to notice what is right in front of your nose. If you are speeding through the day, chances are you are overlooking the blessings that are all around you. No matter what our circumstances, we can slow down enough to notice and give thanks to our breath going in and out, the food we are about to eat, the book we are reading, the kindness of the stranger we bumped into. As we take the time to open our five senses to the world around us, we won't miss the shooting star, the life-altering words, the tiny blue violets.

But how to remember? The trick is to use the goings on in daily life as triggers. In his book Stopping, David Kundtz suggests the practice of Stillpoints, stops for a very brief time, that are made in the "unfilled moments in life": waiting for the microwave to heat your coffee, standing in line, walking from one appointment to the next, sitting at a red light. Sitting or standing, you "stop, breathe, and remember." The remembering can be any message that is powerful and important for you: that you are loved, that you are filled with peace and joy, that you have plenty of time to do what you have to, that you can notice the world around you in this moment. If you are trying to increase your sense of gratitude, perhaps your message can be something like, "I notice the gifts surrounding me in this moment."

Some people once brought a blind man to Jesus and asked him, 'Rabbi, who sinned, this man or his parents, that he was born blind?' And Jesus answered, 'It was not that this man sinned, or his parents, but that the words of God might be manifest in him.' He told them not to look for why the suffering came but to listen for what the suffering could teach them.

— WAYNE MULLER

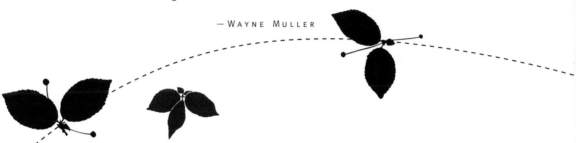

Gratitude is an all-out experience. It's cheating only to be grateful for the good things that happen and to shun the bad. This isn't to say that we *want* bad things to happen to us, just that if we can be grateful for the soul lessons that are inherent in the difficulties that befall us, then our souls will be able to grow and mature. Otherwise, we never progress, because we fail to use the hardships that dog us to become more loving, more patient, more present, more kind.

The people whom I admire most in the world say without reservation that the hardest things they had to face—cancer, death of a child, bankruptcy, job loss—were their greatest teachers and that they were grateful for the lessons.

Right now, write down the ten hardest or most terrible things that ever happened to you. As you look over the list, can you see the gifts that each of them brought? Metaphysical teacher Daniel T. Peralta suggests that when you are suffering from some difficulty whose blessing is invisible to you, you say the following prayer: "I am willing to see the gift in this experience. May the lessons be revealed to me, and may I become stronger and clearer."

Buddha said that fortune changes like the swish of a horse's tail. Tomorrow could be the first day of thirty years of quadriplegia. . . . The more you open to life the less death becomes the enemy. When you start using death as a means of focusing on life, then everything becomes just as it is, just this moment, an extraordinary opportunity to be really alive.

— STEPHEN LEVINE

Whether it is right or not, sometimes it is only the possibility of our not being here on Earth anymore that wakes us up to the beauty of our lives. That's one of the reasons Buddhists contemplate their own death—to awaken to the joy that is available in the present moment.

If this *were* your last day on Earth, would you worry about the clutter in your house or the state of your thighs? I'll bet not. If this were the last day on Earth of someone you loved, would you spend the time arguing about whose turn it is to take out the garbage or who's right about where to send your child to school?

The truth is, of course, that today might be our last day on Earth, because the future is never guaranteed. Too many people go out of the house blithely one day and never return—the victims of car accidents, heart attacks, drive-by shootings, plane crashes, and other catastrophes of living—for any of us to take our continued existence for granted.

The purpose of living as if each day were our last is not to create an overwrought sense of having to grab every experience right now. Nor is it an excuse to ignore the garbage that needs to go out, the bills that need to be paid, the clutter that needs to be picked up. Rather it is merely a reminder to be present to our lives as they unfold, to take in, as much as we can, our daily existence.

What amazes me is that before we can count we are taught to be grateful for what others do. As we are broken open by our experience, we begin to be grateful for what is, and if we live long enough and deep enough and authentically enough, gratitude becomes a way of life.

— MARK NEPO

By now I hope you've come to experience some of the great joy gratitude can bring, and have begun to see that the attitudes and practices of gratitude lead us on a soul journey, one that the quote by poet and cancer survivor Mark Nepo so perfectly describes in the quote on this page.

At each level of gratitude, our soul's capacity deepens. At the first level, we experience contentment—we wanted a cookie and we got it. At the second, we experience meaning—we're here for a purpose and are therefore grateful for all of life's lessons, no matter how painful. At the third, we dwell in pure joy, "the simple response of our heart to this given life in all its fullness," as Brother David Steindl-Rast puts it.

May you experience all the levels of thankfulness and the soul gifts that each offers. For then it will be truly possible to give and receive joy every day of your life.

TO OUR READERS

Conari Press, an imprint of Red Wheel/Weiser, publishes books on topics ranging from spirituality, personal growth, and relationships to women's issues, parenting, and social issues. Our mission is to publish quality books that will make a difference in people's lives—how we feel about ourselves and how we relate to one another. We value integrity, compassion, and receptivity, both in the books we publish and in the way we do business.

Our readers are our most important resource, and we value your input, suggestions, and ideas about what you would like to see published. Please feel free to contact us, to request our latest book catalog, or to be added to our mailing list.

Conari Press
An imprint of Red Wheel/Weiser, LLC
500 Third Street, Suite 230
San Francisco, CA 94107
www.redwheelweiser.com